'Cine

ELECTRIC EARTH

Film and Video from Britain

MARK BEASLEY & COLIN LEDWITH

Contents

Foreword

Andrea Rose, Director of Visual Arts, The British Council, London

Electric Earth is a snapshot — or more appropiately a series of snapshots — of a certain strand in current British film-making. The films that have been chosen by Mark Beasley and Colin Ledwith all reflect on the way in which artists and film-makers have taken on some of the preoccupations of mainstream culture, from the pop video to the film documentary, and twisted them to create a subtle and experimental type of projection: fast, tense, and curiously elusive. The films and videos selected for the exhibition make no bones about blurring or sliding across disciplines or interests — the documentary colliding with the music video, the non-linear film using the giddy pace of skateboarding films — in fact, they use elisions, cross-cutting and mixing as one of their most effective and telling modes of expression.

The fifteen individual artists and collectives whose work has been selected for Electric Earth have been beneficiaries of the extraordinary developments and refinements of editing programmes for home computers over the past decade, and as such, have been able to invent an increasingly sophisticated language in which to create their work. It has enabled them to move in and out of the worlds of pop and advertising videos, artists' films, mainstream cinema and TV documentary with ease and familiarity, appropriating what they want, subverting parts, shadowing others, and using music and sound as freely as they manipulate form and structure.

We are extremely grateful to all the artists included in the show, not only for their generous agreement to lend work for a lengthy international tour, but also for their co-operation at every stage of the organisation of the exhibition. The show has been jointly curated by Mark Beasley and Colin Ledwith, and I should like to thank both of them for the enthusiasm with which they have undertaken the task, as well as for the essays each has contributed to this catalogue. Colin Ledwith discusses the context in which new film and video finds itself today, with an informative look at what preceded it. Mark Beasley provides snappy assessments of the works included in this exhibition, and together they offer a reflective picture of how artists in Britain are taking on new subject matter, and finding new forms in which to do it. My thanks also go to Katie Boot, who has assisted the curators with her customary care and attention; to Robert Johnston for his lively catalogue design; and to Louise Wright, who has managed and co-ordinated the international tour of the exhibition.

Below: from *Powers of Ten: A Flipbook*, Charles & Ray Eames, 1977 (Eames Office, Venice, California). © Lucia Eames/Eames Office

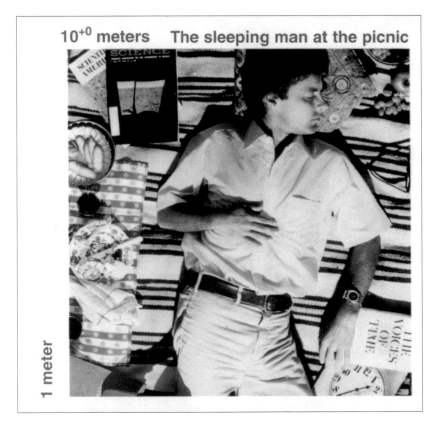

Powers of Ten

Colin Ledwith

In 1977 Charles and Ray Eames produced a short film, nine minutes in length, which attempted to illustrate the interrelated nature of all things in our universe. This deceptively simple, deeply ambitious film was called *The Powers of Ten*. Opening with a one metre square image of a sleeping man at a picnic (10^{+0}), the camera then moves ten times further away every ten seconds to the edge of the known universe (10^{+25}), before the journey is reversed, ultimately reaching the interior of an atom in the man's hand (10^{-18}).

The Powers of Ten is an object lesson in short film making, tightly produced, it seduces the viewer to consider the power of the narrative to express a way of thinking about interrelated things. It encapsulates mathematics, science, physics, art, music and literature and considers how scale operates in our world, how seeing and understanding our world from the next largest or next smallest vantage point broadens our perspective and deepens our understanding.

The idea of exponential growth, or the effect of 'adding another zero' metaphorically ebbs and flows through shifts in culture, the politic of each decade subtly altering as a generation rally against the beliefs and ideals held by those immediately preceding them. The artist Ross Sinclair stated: 'I think that cycles of artists are important, hating everything enough to do something else, the right people in the right context.'[i]

Sinclair voices the attitude which initiates a shift to that which has gone before, the motivation behind change which drives culture forward into new territory.

This drive is aided by new technologies which were previously unavailable to the participant and which free up potential arenas for cultural practice. 8mm film cameras were first produced as consumer items during the 1960s, and they immediately presented a new set of possibilities and ways of working for the artist. Both painting and sculpture demand a respect for the raw materiality of their production; an unspoken collusion on the part of the artist to recognise and acknowledge centuries of history behind the chosen medium when engaged in their own personal production. Whether working in oils on canvas, steel, wood or stone, an artist must first address the loaded signifiers — the materials, before considering the form of an intended piece. Video art is different. A relatively new medium, the weight of history spans some forty years only. Video is not loaded with the century-old historical debates surrounding other materials. Focus can constantly shift as technological advances present the artist with new possibilities. Ambitious, flexible,

ambiguous in territory and nowadays, with the ever decreasing cost of equipment creating an increasing user demand, video is capable of presenting the artist with the possibility of creating his or her own universe through digital graphic manipulation on a standard home computer.

This is a new development within the brief history of video art, the technology necessary only becoming widely available within the last ten years. Early in the 1990s, younger artists started to pick up 8mm and video cameras once again after a period of indifference by many towards the medium during the previous decade, which was driven instead by large-scale painting and sculpture. The ease of use appealed; the camera was a cheap tool with an inherent nonchalance which did not require in-depth technical knowledge to gain good results on screen. Recognising the potential for working quickly and intuitively, artists utilised the camera informally as a sketching tool, documentary device, or to present an idea that is best unfolded over time on a screen or projected onto a wall, resulting in work which had a directness or a sense of gritty reality. Much of the work was modernist in content — exploring ideas of the camera and the possibilities it presented as a raw material, or using it as a tool to record an artists activity — a self reflective practice. The more complex and mainstream broadcasting structures of narrative, editing, and the process of film construction in general were largely overlooked for the instantaneous quality video could deliver. In content and execution, many young artists looked to now influential figures who were working at the inception of video as a medium; the pioneers of the late 1960s and early 1970s rather than the appropriation of film material and ambitious installations of the previous generation engaged in the prevailing post-modern critiques of the 1980s. Artists looking to use video in their practice turned to figures with a conceptual approach who, through the necessity of limited budget and technology, had connected directly with their audience, cutting away post-production to create an immediacy which felt altogether more 'real' for the viewer. The late 1960s and early 1970s performance films of Bruce Nauman experimented with cross-fertilisation in the wake of conceptual and performance art. Conveying simple ideas with a dry humour and often using the empty studio as his set, these early film works were an evident influence on much of the work of the 1990s, Nauman working simply in an intense environment to produce laconic, complex multi-layered short films forming just one aspect of the artists practice.

11

Catalogue cover, 'The Video Show', © Serpentine Gallery, 1975

In many ways, the definitive moment of influence on much video work produced in Britain throughout the last decade, and also the point the medium began to address broader issues through the appropriation of film and video from other contexts, can be traced to two London exhibitions in the mid 1970s. The earliest Serpentine Gallery exhibition held premonitions of appropriated narrative and broadcast styles which are prevalent in video practice post-2000, whereas a later exhibition at the Tate gallery adheres more closely to ideas of modernism which influenced much video art of the early 1990s.

The work of American video makers such as Nauman informed artists in the development of British video art during the same period. As a direct result of the interest generated, the first major exhibition of independent film and video in Britain was staged. The Video Show was a huge, sprawling festival mounted at the Serpentine Gallery in May 1975. Organised by Sue Grayson, The Video Show was an ambitious, colourful event of some one hundred and fifty individuals, artists collectives, faction groups and political activists rather than a traditional exhibition, and included many promising young artists who would later become influential figures themselves, such as David Hall, Susan Hiller, Stephen Partridge, Derek Boshier and Ian Breakwell.

The month long event brought together dozens of community activists and artists, previously working in relative isolation, with a presentation of tapes, installations, performances and lectures. In many ways, The Video Show was very much a product of, and reflected, the concerns of the time. The discourse of counter culture formed the basis for The Video Show. The student revolutions of the late '60s had endowed young people with an extraordinary sense of their own power and the unassailable progress of civil liberties seemed to be guaranteed by the recent liberal legal reforms of the Labour government. Video art was born in Britain at the end of an era of consensus politics which was to be later erased by a decade of popular authoritarianism under Thatcherism.The catalogue of loose-leafed artists statements displayed an innocent enthusiasm through the belief that video artists were witnessing and participating in the beginning of a progressive technological and social revolution. Agitprop video makers referred to 'guerilla television', 'democratic media' and 'the people's tube'.

12

From 'The Video Show' catalogue: *Progressive Regression*, David Hall, © Serpentine Gallery 1975

With hindsight, there was a naive belief that new technologies such as video would, by their very nature, democratise the media by decentralising the means of production; a desire, which David Hall later described as to 'decipher the conditioned expectations of those narrow conventions understood as television.'[ii]

This became the central core of the event, evidenced by the fact that many of the young participants meeting for the first time at The Video Show saw video art in direct opposition to mainstream television broadcasting. The work exhibited often relied on a response to dominant forms of television narrative; engaging non-linear, anti-corporate 'public access TV strategies, or else turned the nature of TV broadcast inward on itself by focussing on the raw technology that made broadcasting possible, creating works which played with this technology in a way the public were unused to seeing. These concerns were mainly explored through single monitor videotape works, but also informed many early installation works such as David Hall's *Progressive Recession* (1975) which used nine closed circuit video cameras to progressively displace the viewer's image ahead of him/her along a row of nine monitors in a manner which played on the viewer's sense of time and space. The immersive viewing experience installation video art provides would become the dominant trend in production through mid 1970s. From the late 1970s onwards, a series of political, cultural and aesthetic debates within video practice resulted in the rejection of the modernist aesthetic; the refusal of representation, and the transformation of modernist reflexivity into the post-modern practice of deconstruction — a shift seen in Hall's seminal piece *This is a Television Receiver* (1976), in which found footage of the news reader Kenneth Kendal endlessly described the technology his image was displayed upon until the image degraded into distortion, was appropriated and given a new context in the gallery.

David Hall once again featured significantly in a second video exhibition of major importance less than a year later in May 1976 at the Tate Gallery. Initially named Video Show, this exhibition is now more commonly referred to as The Installation Show. Organised by Simon Wilson and featuring Tamara Krikorian, Brian Hoey, Stuart Marshall, David Hall, Stephen Partridge and Roger Barnard, The Installation Show concentrated on eight British artists paired off with each other for a one-week run each.

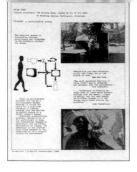

13

From 'The Video Show' catalogue: *Videvent*, Brian Hoey, © Serpentine Gallery 1975

The exhibition gathered together work dealing with video as a primary medium rather than as a secondary means of documentation alone. The exhibition did not present a firm commitment to the new media, never being granted display within the principal gallery space. Instead, the eight participating artists were tucked away in an education department lecture room — perhaps indicative of the suspicion with which video-as-art was viewed.

Tamara Krikorian's *Disintegrating Forms* utilised a number of monitors on high plinths to show a live camera view of the clouds in the sky above the gallery. David Hall's *Vidicon Inscriptions* was a development of an idea he had experimented with in The Video Show. The viewer was both the subject and object of the work. A single black and white camera was mounted on top of a monitor pointing towards a brightly illuminated corner. The viewer entering the lit area caused the shutter to lift and an image of the viewer was burned into the camera's tube. The shutter then closed, and the viewer was able to see his or her image moving faintly in real time behind the frozen 'photograph', which had been registered on the screen. Stephen Partridge showed *Installation 8x8x8* which electronically switched the output from eight live video cameras to any combination of eight video monitors so providing a rhythmic articulation of the viewer moving through the space. Brian Hoey's *Videvent* used a short tape delay to feed the viewer's image back to him or her and so allowed for an interaction between temporally separate images. Roger Barnard's *Corridor* suspended a camera above a corridor entrance to feed a live image to a monitor at the other end of the space. The piece also incorporated a time delay so a viewer would see him or herself on monitor walking the corridor accompanied by the unsettling ghosts of previous visitors. Stuart Marshall used a series of eight video monitors lying on their backs below two viewing platforms in his piece *Orientation Studies*. The monitors showed a repeated pre-recorded image of rapidly flowing streams and rivers which moved through the frame to produce a sense of disorientation. There was a strong sense of what Raymond Williams described as 'technological determinism' in the work — the power and possibilities of a new technological media becoming the central theme. The perfomative and determinist strategies employed in The Installation Show can be seen reflected to greater or lesser degrees in video work produced through the 1990s with artists such as Smith and Stewart, Graham Gussin and Douglas Gordon amongst others.

Whilst it would be too simplistic a reading to imply that modes of operation outlined in The Installation Show do not still have a far reaching influence today, it is perhaps the pluralism of the agenda based The Video Show to which artists look when thinking about their work now. Artists such as Adam Chodzko are concerned with social engagement and the way their work is altered once a proposal is opened up to multiple viewpoints. Chodzko often operates as a director of sorts, offering up his formulated contexts and proposals to a hand picked cast of collaborators to generate his work, his methodology often paralleling that of the artists collective, though political agendas are absent. Chodzko is interested in the individual's perception of an event, or series of ideas, his willingness to acquiesce opening constant unchartered variables on the journey to the completion of the piece.

Likewise, the monitor-based work of Hilary Lloyd relies upon an unspoken agreement of trust between the artist and her subject as Lloyd often asks the participant for ideas on how they would like to interact with the camera. Often complete strangers, Lloyd is drawn to an indefinable aspect of her chosen collaborators personalities before asking them to perform a simple group or solo task before the steady gaze of her video camera. Elsewhere, the broadcasting parameters of public access television informs the work of Paul Rooney, while the appropriation and manipulation of broadcasting material first used by Hall has informed the work made by the likes of Mark Leckey and Luke Fowler. Others, such as Payne & Relph, Stephen Sutcliffe, Eichelmann & Rust, Lauschmann and Deller & Kane, harness the broadcasting structures of the pop promo or the documentary genre.

The pervasive nature of these dominant models of imagery has created a situation where, in varying degrees of directness, artists video is positioned against the accepted structure of mainstream film and television and in doing so, nearly 30 years later, reciprocate the concerns The Video Show attempted to define. The explicitly alternative agenda of the artist from the mainstream image maker coupled with new affordable technology capable of emulating mainstream production values ensures that video offers subtle and sophisticated opposition to, or collusion with, the dominant narratives and stereotypes embodied within mainstream moving image media.

In this sense, the works in Electric Earth aim to stimulate questions on the nature of our received expectations of broadcast film and video. The correlation between the large screen presentation of work in the exhibition and our associations with mainstream

15

cinema is therefore more than coincidental. The usual anticipation of the parting curtain, the glitch and pop of the black screen leader proceeding a cinematic feature presentation, are replaced with the artists subtle interventions, twisting and blurring expectation and taking the viewer on a journey into unfamiliar and often uneasy territory in the darkness. Electric Earth is therefore an exhibition of possibilities at a time when digital technology has made everything possible, yet the resulting work is not insular or technology obsessed. Instead, it looks to social constructs, religious faith and political agendas for concerns, all the time subtly questioning the nature of our faith and our systems of belief.

NOTES

i Conversation with Ross Sinclair from 'The City Racing Decade', *Untitled* no.24

ii 'British Video Art — Towards an autonomous practice', *Studio International* vol.191, no.981

Earache My Eye!

Mark Beasley

In the early 1980s artist Rodney Graham expressed a neurotic dislike of cinema. Neurotic in the sense that as the dominant art form of the Twentieth Century, cinematic authors could 'claim to effect a much larger audience in a deeper way'. The implication was that as a 'visual artist' Graham felt he was 'involved in something a little too rarefied, elitist and out-of-date'.[i] Twenty years on and artistic relations with the moving image are in the process of redefinition. As I write, Matthew Barney's *Cremaster* cycle is top of the bill at the local cinema, and user friendly film-editing programmes sit comfortably on the computer desktop.

The current situation (at least in the UK) could be said in part to stem from technological advance. The advent of affordable PCs and compatible editing equipment has seen the bedroom become the production studio for a new generation of film and video makers. Hundreds of pounds rather than thousands are all it now takes to satisfactorily unite sound and vision. Digital video allows artists to craft their vision of the world from home. The ability to shoot ad infinitum at low cost, erase and rewind, has resulted in a mini-revolution in cultural production.

Electric Earth is a portrait of filmmaking to the extent that it reflects certain shifts within broader culture, from the rise of the pop video to the renewed interest in the documentary format. The exhibition equally reflects the accelerated blurring of disciplinary boundaries. The investigative spirit of the documentary collides with the music video, while the non-linear film utilises the giddy pace of the skate-promo. Unravelling the multitude of images that slide through our consciousness on a daily basis, artists have chosen to adapt existing forms as means for intellectual and emotional exchange. Activity that gives scant regard to the bankrupt philosophy of 'Knowing one's place'. Is this what the first punk-poet Rimbaud forecast in the lines, 'Rumblings and Visions! Departure into new affection and new sound!'?[ii] Rather than drown under a sea of manufactured ideas, it is perhaps an attempt to re-order the fit of the world, to muddy the waters and occupy previously privileged territories.

Removed from the need to sell product, the music video has been reconfigured as a contemporary narrative device. Arriving in the mind long before the visual settles on the retina, music cuts through the red tape of communication. It is an expansive and rich language that can be as referential and descriptive of the world as visual imagery. A recent spate of documentaries released on the big screen, notably Stacy Peralta's documentary epic

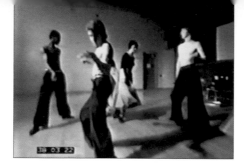

18

Fiorucci made me hardcore, Mark Leckey, 1999

Dogtown and Z boys (2002) and director Nick Broomfield's diffident style, have exploded the fragile construct of the 'objective documentary'. The influence of filmmakers such as Chris Marker and Patrick Keiller are also evident in the encyclopaediacal desire to make connections between people, places and practices. Rather than studio bound performance to camera, artists have chosen to present 'real life' histories on-screen. Yet, perceived reality is constantly checked from supermarket shelf stackers, skateboarders, city workers and gallery assistants to the life of psychoanalyst R D Laing. Removed from the need for objective truth, lives are complicated and skewed in an attempt to define new relations to given situations. The documentary in this sense is never straightforward. Many of the works re-sample former texts, a technique that finds its parallel within music culture. Artists are jumping directly to root influences and stretching taught the content of the original. Connecting, as Greil Marcus suggests in *Lipstick Traces*, the 'echoes' of the past with the conversation of today. This is a generation at ease with the flick of the remote control, adept at receiving and transmitting visual non-sequitors. In this sense Electric Earth reflects the role of the artist as a mediator or editor of existing visual signs. Simply put, it is the desire to shift the focus of discussion one foot to the left or right of the main picture.

Fiorucci made me hardcore (1999) is the music documentary Mark Leckey would like to see on TV. A low-tech edit of found footage, it spans three decades of UK dance subculture. Kids in loon pants spin to the sounds of Northern Soul, while the eighties Soul boy — the 'football casual' — takes to the street in muted pastels and wedge haircut and the glassy eyed-raver signals wildly to the aliens. In part-homage to the dance subcultures that inspired him, *Fiorucci* speaks on behalf of those underground scenes seemingly overlooked or misunderstood by mainstream discourse. Leckey's portrayal is indebted to the energy of youth, an attitude and aesthetic comprised of box-bedrooms and cheap editing equipment. It's a search for another truth, a hypnotic ballet of spiralling bodies trapped in the moment. Sat in the darkened room, the gallery is altered as the cut up images breathe life into the delicious cliché of being lost in music — a feeling many find hard to articulate. It is, as the writer Raymond Williams may have surmised, the depiction of a 'whole way of life', from the peak experience to the inevitable comedown, a muttered mythology made flesh.[iii] *Fiorucci* is a visual essay of 'teenage kicks' throughout the decades.

19

Mixtape, Oliver Payne & Nick Relph, 2002

Youth and pop-culture loom large within Electric Earth. A history of activity shored up by the texts of Greil Marcus, Michael Bracewell and the distant echo of Hebdidge's seminal *SUBCULTURE — the meaning of style*. As Barthes reflects on the object: any attempt to truly articulate the experience of youth or street culture is thwarted by the knowledge that in doing so something is necessarily lost in translation. Somewhere between the street and the page bound description; Oliver Payne and Nick Relph's *Mixtape* (2002) attempts through a visual and aural onslaught to catch critical theory off-guard; to remain kicking while in the gallery. Set to the screaming chorus of Terry Riley's *You're No Good* (1967), it is an ode to the energy of youth. Potent images settle then disappear, well spun media clichés mix with moments of surreal authority. A teen Metal band scream their way through a rehearsal set. A young guy grips a lit sparkler in his teeth as the camera settles on a memorial wreath at his feet. A wreath to the passing of youth perhaps? Two kids in outsized trainers and peaked caps ride a scooter on a running treadmill. A pierced worker at Starbucks covers her facial ornaments with regulation blue sticking plasters. From youth in stasis to youth gone awry, *Mixtape* travels a breathless journey that en-route name checks Lee Scratch Perry, Harmony Korine and the texts of Huysmans. The inflections of street style dazzle the viewer, momentarily understood before dissolving as the eye grapples with the next image.

In Wolfgang Tillmans' first video work, *Lights (Body)* (2002), the lighting rig of a nightclub flickers to a generic House sound track. The nervous twitch of an octagonal mirror reflecting a shimmering sequence of colour spectra high above the dance floor. Electronic pulses respond to the music and metaphorically suggest the movement of bodies on the floor below. The rush of adrenaline as a favoured anthem climaxes in a spectrum of on-screen flashes. The video speaks in absence of the body. What is imagined is the responsive twitch of the flailing clubbers below. Tillmans suggests the intimate relation between music and the body via the automated and prescriptive flicker of stage lighting.

Moving from the momentary high energy of the dance floor to the end of the night, Paul Rooney's *Lights Go On* (2001) reveals the twilight existence of a night club cloakroom

attendant. As fluorescent lights flicker into life, we are privy to a world of beer-swilled dance floors and skeletal coat hangers. The attendant wearily recounts in song, her alternating roles as both agony aunt and zip fixer. In *Around, Between* (2001), Rooney presents the lonely life of the gallery invigilator. Empty galleries and endless corridors provide a backdrop for a vocal tale of barely concealed boredom and unsettling paranoia. Wistful shots of windows to the outside world suggest dreams of escape. Eschewing glamour for ordinariness, Rooney presents centre stage the thoughts and deeds of Britains peripheral cultural support workers.

The narrative-driven music video of the 1980s is also key to Stephen Sutcliffe through The Smiths in *Please, Please, Please, Let Me Get What I Want* (2002). Filmed in real time, the camera tracks an endless line of supermarket aisles, consumer goods and night time shelf stackers as The Smiths track plays on the in-store tannoy. Morrissey's lyrics 'Haven't had a dream in a long time' punctuate the calm still of the late shift. A comment perhaps upon consumer cultures denial of imaginative desire, or a dark satire on the dead end job? As with Paul Rooney it is a beguiling take upon British ordinariness or, as Bracewell describes, the 'defiance of hopelessness'.˙ Sutcliffe — a former shop worker — combines the heritage of British social realist film with the brooding lyrics of Northern pop to create a thoroughly modern 'Saturday Night Sunday Morning' for the late night shelf-stacker.

Rob Kennedy's *The Truth and the Light* (2000) buzzes with the malevolent energy of a John Carpenter movie — imagine Precinct 13 pre-assault. Shot upon a deserted German Autobahn, the film is predicated with a sense of desperate isolation. A brave new world comprised of empty gas stations that glow in the night. The drone of unseen traffic makes way for the crackle of Kennedy's digital sound track. As distant headlights shimmer on the deserted canopies, automated doors slide open welcoming invisible guests. The service station, the welcome stop off point, is reduced to a crackling neurotic rush of sparking lights. Kennedy's vision is of an unsettling automated world that awaits human inhabitation, silent monoliths created to fulfil uncertain desire.

Let's Kiosk (2001) is Torsten Lauschmann's letter home from Japan. Shot on the streets and subways of Tokyo, Lauschmann battles with an endless stream of digital and human traffic. From Manga cartoons to pedestrians on the street; the soundtrack of wailing sirens, electronic squawks and video games overload the senses. It is an attempt to decode the hidden order of the city, a journey that reflects the mix of modernity and

21

What You See is Where You're At, Luke Fowler, 2001

tradition of contemporary Japan. As the camera skims the surface of the city, it settles upon the tiled pavement, searching the cracks for hidden meaning. Lauchsmann is a man alone — a tourist fighting to make sense of his new environment.

Initiated in 1999 Folk Archive, organised by Jeremy Deller and Alan Kane, is an ongoing archive of folk art from Britain. Shifting focus from the gallery to the street, video footage reveals a breadth of cultural activity just off the beaten track. A terraced house daubed in painted protest. A surreal game played by villagers involving an outsized football. A denim jacket that immortalises favoured musicians in marker pen. From drive-by footage of suburban streets to the centre of mass gatherings, Deller and Kane's video diary reveals a world of cultural activity that until now hasn't made it to the gallery. Curiously voyeuristic, the video denies overt judgement. Rather, it stands in bemused yet respectful awe. As the theoretician Frantz Fanon writes 'a national culture is not folklore' or the 'inert dregs of gratuitous action'; rather it is the ongoing activity of a body of people.[vi] Through the estranged relation of the camera, Deller and Kane provide a beguiling account of existing 'folk' culture that is anything but inactive.

R D Laing's experimental 'anti-psychiatry' commune at Kingsley Hall (London, 1965–69), provides the content for Luke Fowler's documentary *What You See Is Where You're At* (2001). The 'romantic shadows' of archive footage reveal a world of seeming chaos. Cut-up digital sound, replaces the classical music of sixties TV documentaries amplifying the emotionally fraught environment of the commune (Laing viewed the state of madness as an attempt by the individual to spontaneously cure themselves of the ills of the world). A surreal landscape of screaming patients and graffiti-scribed walls propose creative expression in all its forms as central to Laing's definition of the healing process. The poetics of despair are literally registered on the walls as the camera reveals the lines 'Your dreams they melt in the Sun' and 'Sign and symbol alone is sane'. Fowler's video gives voice to the pervasive and influential legacy of Kingsley Hall, holding the question of Laing's life and adherent ideals aloft for re-examination. Perhaps, as Fowler appears to imply, there is method in madness?

In Carey Young's *I am a Revolutionary* (2001), a motivational trainer assists the artist in the rehearsal of a 'revolutionary' speech. Replete in a navy-blue power-suit, Young is framed against the glazed atrium of a corporate office block. Corporate presentation and

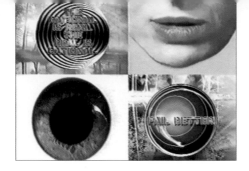

22

Artists are Cowards, Mark Titchner, 2002

radical politics crunch as Young falters with the weight of the statement 'I am a Revolutionary'. Comic frustration makes way for the unsettling recognition of the staged impotence of her assertion. The spin is revealed, as her trainer appears far more able to play the role convincingly. Young appears to share something of Debord's frustrated declaration 'Revolutionaries everywhere. No-where revolution.' [vii] A bleak take on revolutionary rhetoric and the corporate co-option of dissenting voices, Young poses the question is it still possible to speak of alternatives?

The seemingly opposed states of activity and stasis are key to Mark Titchner's animation *Artists are Cowards* (2002). A migraine-inducing series of images and half-registered texts revolve and flash on screen. A goldfish circles endlessly — a lesser-known Duchamp rotorelief — overlaid with Beckett's text 'Fail Again, Fail Better'. The Vertigo record logo — home of Black Sabbath — spins anti-clockwise, an unlikely backdrop for Hegel's tautology 'The Rational Is Real. The Real Is Rational'. A conflict of ideologies that conflates the urban myth of Vertigo records played backwards summoning the devil, with the static certainty of philosophic thought. Squatting the collapsed space between philosophy and pop culture, Titchner attempts to re-wire seemingly irreconcilable texts. A bizarre training video for the activation of the individual, Titchner's visual proposal is something like the schizophrenic hearing voices pre-action. Imagine Burgess' lead droog Alex in *A Clockwork Orange*, eyelids peeled back as images strobe on screen, the unwilling victim of radical re-coding.

'The characters and incidents portrayed and the names herein are fictitious and any similarity to the name, character and history of any persons living or dead, is entirely coincidental and unintentional.'
(*Loose Disclaimer*, Adam Chodzko, 2002)

Lit by the amber glow of a distress flare, a woman is seen holding Adam Chodzko's makeshift disclaimer. *Loose Disclaimer* (2002) is a DIY reminder of the artifice of film. Originally spliced at the end of hired video films Chodzko's additional disclaimer collides with the blunt reminder of the filmmaker that what we have witnessed is, after all, 'only a film'. The conceit that Chodzko's hand held footage is closer to reality forces the viewer to question again what has just occurred on screen. Like the hidden track on a favoured

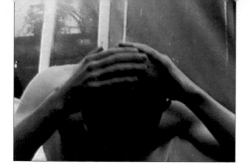

23

Rich, Hilary Lloyd, 1999

album, or a scribed text on a vinyl run-out groove, Chodzko communicates from the margins. It is a beguiling reminder of the space and slippage between fiction and reality.

A portrait of the rites of passage, Hilary Lloyd's silent film *Rich* (1999) reveals the naked torso of a teenager as his head is shaved. The gloss red paint of a door illuminates Rich's pale flesh as, head bowed, an unidentified figure passes an electric razor across his scalp. It is a moment of quiet initiation, a Larry Clark still come to life. 'In effect the cinema is basically immodest. Let us use this faculty to enlarge gestures. The cinema can open a fly and search out its secret.'[viii] As Genet attests, film has the ability to present intimate moments in exaggerated detail. A willing victim of the razor, Rich's close-up gestures reveal the faith he has in his older mentor. Lloyd, in gaining the trust of her subjects, is party to an unspoken initiation ritual as the boy sheds one lifestyle for another. Or simply changes his haircut.

In Szuper Gallery's *Nirvana* (2002), the sterile environment of an immigration building provides the stage for a surreal encounter between office workers. As Szuper Gallery's electro-pop plays, a woman taps the high heels of her boot against a closed door. Dressed in pink shirt and striped tie, a young man slumps pensively to the floor. Two women crawl on all fours across the blue linoleum of the office floor. Formal office relations explode in a display of flailing limbs. The cliché of the red-lipped office vamp is pushed to its limits as, legs spread, a woman in fish net stockings rolls seductively against the wall. The stifling environment of the immigration office is transformed into a libertarian playground. It's a beguiling take upon arts potential relation with corporate structures.

As other artists scour the city in search of meaning, Volker Eichelmann and Roland Rust drift towards the edges of landscape. Waves of clear water crash on a pebbled beach, sunlight sparkling on the foam. Figures trudge wearily through snow blizzards. A chalk horse carved high on a hillside appears through a misted car window. Through a sequence of New Age imagery we return to the land in search of answers in the patterns and rhythms of nature. Bouyed by a diverse soundtrack, *After All* (2002) tugs at the emotional core of the viewer. Impregnated with a pervasive melancholy, Eichelmann and Rust propose a moment of psychological release, to let go and drift within the image. A narrated excerpt from Douglas Coupland's *Microserfs* recounts computer programmer Ethan's desire to take an 'identity holiday' to escape momentarily from his own psyche.

'You know, pal — maybe I should de-wire myself. De-wiring would reconnect me to the world of natural time — sunsets and rainbows and crashing waves and Smurfs.'[ix]

It's an appealing thought. Maybe part of the 'de-wiring' process is to look again at the world with fresh eyes. We all exist within the world, yet on occasion appear exiled from it. Perhaps through the moving image and the relative freedom that digital video provides there is the opportunity to re-order the priorities of the modern world. Either through fleeting engagement or pro-longed study. To rewire certain aspects of visual and social culture that have been hidden, disregarded or simply overlooked. If not necessarily to escape, then to ask questions of the world via the shifting gaze of the digital image.

NOTES

i Rodney Graham interviewed by curator Anthony Spira, The Whitechapel Art Gallery programme, September 2002

ii Arthur Rimbaud, *A Season in Hell*, Trans. Mark Treharne, J M Dent, 1998

iii Raymond Williams, *The Long Revolution*, Penguin, 1965

iv Roland Barthes, *Mythologies*, Paladin, 1972

v Michael Bracewell, *England is Mine*, Flamingo, 1998

vi Frantz Fanon, *The Wretched of the Earth*, Grove Press, 1963

vii Greil Marcus, *Lipstick Traces — a secret history of the Twentieth Century*, Harvard University Press, 1990

viii Edmund White in Jane Giles, *Criminal Desires: Jean Genet and Cinema*, Creation Books, 2002

ix Douglas Coupland, *Microserfs*, Flamingo, 1995

Mark Beasley & Colin Ledwith
in conversation

COLIN LEDWITH: I wanted to begin with a quote from cultural theorist Frantz Fanon; a man with a very different personal background to either of us, though I feel Fanon's thought is one which can be read as a universal:

> 'I cannot go into a film without seeing myself. I wait for me. In the interval, just before the film starts, I wait for me.'

Fanon is voicing the need we all have for identification with the experience being viewed. We search for a way to position ourselves as viewers in the scenario playing out on the screen before us. We need the emotional charge that comes from identification perhaps. I wondered if you felt Fanon's view has been an integral element in your experience of organising this show with me. The selection of work is something we agreed upon after much discussion, but I also feel the content is rooted in a personal context for both of us. Much of this lies in our mutually received experience of culture; be it youth culture, corporate culture or alternative modes of living.

MARK BEASLEY: It's true to say that our own cultural background or histories have inevitably informed the selection of works. The desire I guess, is to share something of our own interests and enthusiasms, hopefully these connect with an audience. Fanon's statement reminds me of Morrisseys' lyrics in *Panic*. We're all looking for connections, for a moment that says something about our lives. There has to be an acceptance of your experiences and the knowledge those experiences provide. It's apparent in the subject choices of the majority of artists, they understand the territory — this concept is often referred to in writing for instance.

CL: We're all familiar with the concept of 'writing about what you know' when considering a piece of creative text.

MB: Yes. Take writers like Raymond Carver or Richard Brautigan for instance — good novelists because they talk from experience. You have the tangible feeling that they know their sources intimately, with Carver's work you believe in the world he outlines and in

his characters. Beyond our curatorial involvement it's important to remember — as the writer Dave Hickey states — that 'somebody has to do something before we can do anything'. As curators we're implicit in the framing of the exhibition, but ultimately responsive to the work that's being made. It's the artist's decision to squat the screen and occupy the territory that's appealing.

CL: Your fiction writing parallel is interesting in that I feel the work also strongly references another cultural framework; that of musical structure. In loose terms, the freeform experimentation found in jazz, minimal electronica and hip-hop is referenced. There's also a definite 'grunge' element to some of the video work, whilst early Motown is used in soundtracks, disco and dance culture features heavily too. There's also an immediacy to the pop promotional video language used to sell music culture — these artists seem very comfortable with that language.

MB: Maybe there's recognition of music's ability to cut through the red tape and get straight to the point. Music can immediately express a specific standpoint, from an artist's attitude to their emotional intent. There's also a sense of the energy of music production from the DIY cut-up to sophisticated re-sampling. In this sense, the artists selected seem to be picking up on a vernacular that they see around them. The works also reflect a shift in production from the fixed-frame one-liner 'art' video to the loose narrative of pop video; social documentary and video diary. They're useful delivery systems for new thought.

CL: Yes; I recall you using the term 'cultural mining' to define an artist re-contextualising something culled from the broader context of cultural production by an earlier generation, and creating an entirely new focus away from the original context. This is apparent in much of the work. You often see the visual equivalent in mainstream cinema or advertising now — particular shots or narratives that reference other older films; a subtext to a work, which asks if you know your cultural history, an interconnecting moment for the viewer to participate in if they have the background knowledge.

MB: This is true, it's an attempt to connect the dialogue of the past with the present. Look at an artist like Stephen Sutcliffe. The language Stephen employs relies upon some

understanding of The Smiths as well as the narrative driven structure of early 1980s pop video. He utilises the narrative idea of conveying the story in the song lyric through visuals, but he's flipped the context and found an environment that instead complicates the lyric of the song in an unexpected way. It gives the lyric a new, edgier meaning.

CL: The Coen brothers do something similar in all their work, but most notably in *O Brother Where Art Thou?* (2000). A black comedy based on the narrative structure of Homer's *Odyssey*, *O Brother* was also the fictional film which the fictional movie director character John L Sullivan wants to make at the end of the Preston Sturges film *Sullivan's Travels* (1942). It's a neat twist that the Coen's finally make the film and reference many of the scenes from Sturges own work. Francis Ford Coppola is just one director who makes use of a soundtrack at odds with his imagery all the way through *Apocalypse Now* (1979), So I guess I'm saying that this is something that can be read as a very mainstream cinematic technique.

MB: True, but perhaps these techniques are often used in opposition to the surface gloss the mainstream often imposes. Mark Leckey has said that he wanted to make a film about club culture, which felt real for him; the documentary about dance culture he'd never seen on TV. An honest film about what it's like to be in a sweaty club with a bunch of people into music and clothes. It's an alternative to the slick broadcast material we're all used to. The resulting film is something like the best night in a club without being in a club. I'm conscious that we're talking a lot about youth and club culture, while this is a strong element of the show there's a number of other worlds reflected on-screen.

CL: There are certainly a diverse range of viewpoints represented, though to close on the youth culture theme, we should talk about Oliver Payne and Nick Relph as they occupy similar territory to Leckey and Sutcliffe. Payne and Relph's work *Mixtape* has an incredible energy generated in large part by the intelligent use of visuals to a soundtrack building throughout in its audio assault. I recall Oliver said he had read a review of *Mixtape*, which stated the piece was a meditation on 'youth under siege by youth culture' — which could be read as taking an alternative stance on preconceived notions that youth is often complacent. Mark Titchner is interesting in that he creates work which positions itself somewhere between the rigorous corporate structures Carey Young employs in her

work, and that of youth culture. Titchner draws the viewer's attention to the politic in a situation, usually through existing texts or use of appropriated logos.

MB: The alternative standpoint is still a tenable position, though many would have us believe this isn't the case. To not recognise the possibility or potential for change seems a curiously redundant position. I think a number of the works ask questions of established norms and challenge the status quo. Standing up and voicing concern, however it shifts culture is valid. I think most people feel they have little control over entire systems that govern our lives, but these actions can at least bend the direction of those forces slightly.

CL: Much of the work operates in ambiguous territory and positions itself in the margins, pushing people's expectations slightly off course. I think in many ways, the exhibition attempts to define a notion of reclaiming some definition in resisting dominating power structures, or to give voice to the dispossessed. To be effective in this way is difficult. The public are familiar with the tactics political and cultural forces use to engage society. Suspicious of political agenda, the public is often on guard, making it very difficult to shift cultural expectation. Luke Fowler seems to address this issue with his film of R D Laing; a man who was dismissed by many in his own profession. Thinking about many of these works, there is an element at odds with the Fanon quote we began with — that of the exotic. I'm using the term 'exotic' to define something that is outside our personal scope of experience here. The fascination of encountering other peoples lives; though Fowler for one also makes us implicitly aware of the extreme prejudice Laing suffered.

MB: Again it's offering an alternative. Laing was a radical thinker who attempted to re-appraise systems of social control. Perhaps if we no longer feel able to effect change, there is at least room to ask questions, to glance over the shoulder at those figures that had an impact.

CL: To change the direction of our conversation slightly, what are your feelings concerning this exhibition being strictly film and video at a point where single media shows are not fashionable?

MB: Initially, defining the exhibition through its medium seemed strangely old-school and perhaps out of step with current thought. Most of what I do attempts to complicate systems of reception, to break down given boundaries. I guess in part the decision was a pragmatic one and reflected the touring nature of the exhibition. Working with a given frame became strangely liberating though. It allowed us a freedom to experiment with content. What we actually found when we went and looked at the work being produced was a renewed energy within video partially led by cheaper technology but also by the fact that it's a medium we all readily understand; the cut-up editing, the fast-forward. In these terms, artists are now producing work utilising broadcast formats; the work actually addresses the medium used to produce it.

CL: Once again we can refer to creative writing; the cut-up and fast-forward narrative being a device heavily employed in the works of another influencial writer — William Burroughs.

MB: Something like the visual equivalent of *Cities of The Red Night* or the revolutionary prose of Brautigan's *Trout Fishing In America*. In terms of cinema, influences range from Chris Marker through to Ken Loach and writer/director Harmony Korine. He's an obvious influence on Payne and Relph. I was recently reading about the writer Genet who had a lifelong fascination with cinema. In 1959 he directed his only film, *Un Chant d'Amour*. Strangely for someone so adept at the written word, the film was silent. Rather, he was interested in film's ability to reveal intimate moments without the need for narrative. It bears a strong relation to Hilary Lloyd's *Rich*.

CL: *Rich* is a colour saturated Super-8 rites-of-passage film. A young man having his head shaved by what appears to be his friend and mentor, in order to be more like him perhaps. It's a simple, yet very complex moment.

MB: But as well as the language of the film-maker, new technology is also an influence. Every bar has a TV or video projector now, we're surrounded by screens. There are also random, DIY, ad-hoc urban situations in which you encounter screen-based culture. From

projections of football matches on whited-out pub windows to club-visuals projected on makeshift screens.

CL: Direct playback in distinctly 'lo-fi' surroundings is possible nowadays, whereas technology was high-end and precious before. The language of technology has changed due to ever decreasing hardware costs. The viewer can encounter films in social settings, as with the Stella screen tour where feature films are projected in settings intended to heighten the viewer's experience. *An American Werewolf in London* (1981), is being screened at the disused Aldwych underground station soon. There's a scene in American Werewolf actually shot in the station. These situations open dialogue and extend the discussion further. Possibilities expand. On the way here I noticed that Matthew Barney's *Cremaster* cycle is showing at the Brixton Ritzy. His work is not so obvious in the questions it poses, but he's an artist who has certainly expanded our understanding of what cinema, and artists film, can be.

MB: It's great to see films like *Cremaster 3* sharing the bill with mainstream movies and to see people responding to it. *Harry Potter*'s got its place but I think alongside that there has to be a place for more demanding and difficult pleasure. It's not about easy entertainment. I think people want to be challenged as well. Cinema and film are still, for me, one of the most rewarding experiences. Maybe it'll be the 21st century's greatest art form as well as the 20th's.

CL: I find the *Cremaster* films very visually seductive, yet steeped in rhetoric and mythology drawn from all sorts of sources. Watching a Barney film feels akin to looking at a renaissance painting, which might be viewed as an overstatement, but I can watch his work and enjoy the beauty, yet know there's an intricate framework of information underpinning the imagery we see. Barney talks about the *Cremaster* cycle representing the progressive curve of a simple 'idea'. From conception of the idea, through contemplation as to whether the idea is a good one, it's possible rejection, until finally the idea is accepted; the point where action must take over from the thought process, or where the idea is made manifest. I like the idea that he has dedicated ten years of his life and all that imagery and

tape trying to convey visually the human thought process. The entire cycle is a grand metaphor for creative gestation. Barney's work, for me, seems to embody many of the issues concerning the artists in Electric Earth.

MB: Payne and Relph do something similar. Reading about *Mixtape*, I realised there's a reference to Lee 'Scratch' Perry that completely passed me. It feels OK though, what appears more relevant is their ability to pick you up and carry you on a wave of pure energy. You know; the more I think about it, the more I think this exhibition is really about 'jumping in.' There are those who will always stand on the sidelines and watch from a distance. Then there are those who immerse themselves — jump right in and lose themselves in the moment. Those people understand the experiences they're talking about. Curatorially, I always associate with the audio-addicted kid who's lost in music.

ADAM CHODZKO

Loose Disclaimer — 2000, six 1-minute films

THE END

Contract for Flasher;

......so, for a while now
I've been recording bits of Hi-8 video
footage on the end of films that I've
hired from video shops.
I then return them to the video store
and imagine the next person to hire
the film leaving the tape running,
and discovering my signal.
There are now lots of these dispersed
around London video shops.
I only record onto the section of surplus
black tape that doesn't carry any image,
a few seconds after the credits finish.
I film distress-signal flares, which
illuminate an environment for about
50 seconds. They are set off in darkness
on a mountainside, in a pine forest,
in a garden, etc.... So, this secretes
a really bright sequence into that black
space; and when the flare burns out,
the tape returns to darkness.
I have to be careful that I don't get caught.
This contract is for you to choose a film;
I hire it; record the 'flasher' sequence ,
I'll show it to you, then I return it to the
video store. You keep this contract.
You can keep quiet about it.

Above: *Flasher 5*, 1998; Right: *Loose Disclaimer*, 2000

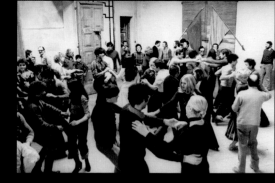

ABOVE is a production still taken by Deborah Beer in 1975 during the making of Pier Paolo Pasolini's *Salo* or *120 Days of Salo*. I found it when I was doing research in 1997 for some work I was making. I had been looking for evidence that all was well in Pasolini's film and here was the proof: the cast/crew party, an occasion where all the hierarchies within the subject of the film and the making of it become horizontal. 'Dead' girls dance with the guards, who 'killed' them, Pasolini dances with the make-up artist, all in a room of the castle where the film's atrocities took place.

But I later found out from one of the sixteen adolescents murdered in the film (the only member of that group I had found who participated in my 'reunion'), that this cast party although 'real' was also filmed and was intended at one stage to be the final scene of the film. When the credits rolled this scene would accompany them. So everyone would know that all was OK. My interest in it is very specific; It's about wondering, or trying to empathise, with a teenager who has just been filmed being tortured and killed who is then having fun at the cast party. The party is filmed, so it will appear self-conscious maybe, and so verges on fiction. But the enjoyment is still real, so what about the 'torture'? Pretending and doing-it-for-real encircle each other very closely here. It was very tricky for me to find a single apposite image. I'd think about a group of people within a Breugel painting, but only in relation to the sound of early Trax records, or I'd remember what I thought the first time I saw someone wearing some Christopher Nemeth in 1986, though only in relation to the conversations I had in Brussels with people who talked of a subterranean city there. So, my interest was in the movement between things at the 'edges'. And it's just about there in the dancing in this image.

Adam Chodzko

VOLKER EICHELMANN
& ROLAND RUST

After All — 2002, 15 minutes

MISTRUST when you don't know, suspect when you do.

Volker Eichelmann & Roland Rust

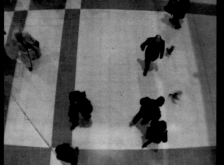

WE AIM to highlight and preserve some of the undervalued cultural production of individuals in the face of the increasingly aggressive consumer society we inhabit, and investigate how this production may be adapting to a rapidly changing world.

(First published in *Intelligence: New British Art 2000*, Tate Britain)

Folk Archive

Above: the Cwnni Gwerin, Pont-y-pwl, Mari Llwd, 2001 (left); the Llantrisant, Mari Lwyd, 2000

Luke Fowler

What You See is Where You're At — 2002, 28 minutes

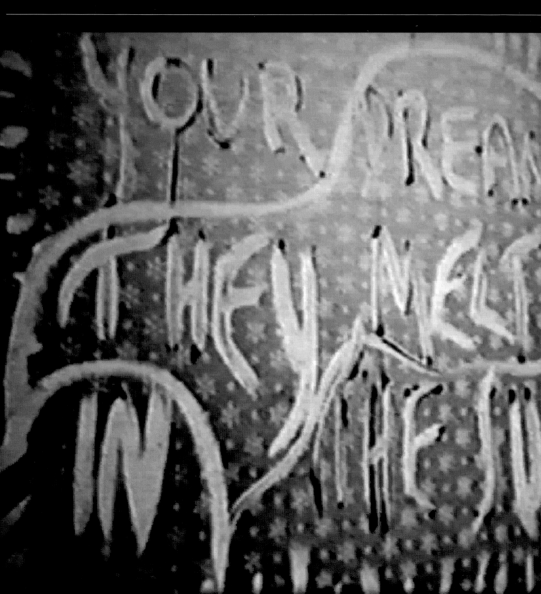

The man who said the mad weren't mad

LUKE FOWLER contacted me when researching a proposed film inspired by the pioneering work of the psychiatrist, psychoanalyst and writer, Ronnie Laing. He'd heard that I had been part of the experimental residential community at Kingsley Hall.

That experiment constituted a daring and innovative approach and response to 'madness'.

A breakdown, perhaps of a way of being that was no longer tenable, perhaps a breakdown of a way of not being oneself, was seen as a possible beginning of a breakthrough to the healing of the fragmentations and disturbances of mind, body, soul and spirit.

Conventional psychiatric diagnosis (rarely the 'seeing through' implied by its etymology), in reducing complex experiences within particular social contexts to categories of illness, could not do justice to the complexity and depth of the experiences of many people in mental distress. Conventional treatment, while often getting dramatic 'results' with people who were disturbed and/or disturbing to others, too often suppressed, obfuscated or deferred the facing up to urgent, painful and perplexing emotional, existential, spiritual and ethical issues.

At Kingsley Hall, people were allowed to find their own way, in their own way and in their own time, whether on their own or in whosoever company they chose to keep.

Was the Kingsley Hall experience a 'success'? It was and it wasn't, depending on who you were, where you were at, and what your point of view was as to what constituted 'success'.

It was a 'success' in raising questions that need to be asked in every generation; what do we mean by 'sanity' and 'madness'? On what basis, and involving what and whose interests is that distinction made? What's at stake for which of us in how such questions are asked and answered by each of us and by those empowered to pronounce and act on these matters?

It was a 'success' in so far as it gave space and respect to the human spirit's insisting on enquiring into who we really are and what might be better ways (than our usual ones) of being-in-the-world with one another, especially when in real distress or on difficult 'journeys'. Such spirit resists and pushes against the constraints of convention and transcends temptations to deaden our pain and anguish without thoughtful consideration, and weighing in the balance, of the cost of such deadening with regard to a passion to live with greater integrity, vitality and responsibility.

Luke Fowler was attracted by the courage, drama, pathos, poetry and sometimes something very like surrealism unfolding between the diverse characters at Kingsley Hall. I hope his work encourages people to return to Laing's texts and rethink the matters he addressed, matters that matter no less today than they did then.

There's a lot more at stake than we might realise.

Leon Redler, M.D.

ROB KENNEDY

The Truth and the Light — 2000, 6 minutes

...ph photograph of Theodore Kaczynski's 'wilderness hut' being delivered to Mather Air Force Base, near Sacramento in order to allow inspection by the jury in the 'Unabomber' court case.

In order to give the jury a first hand experience of the hut, the exhibit has been laboriously delivered to them. The hut, removed from its original environment, becomes an obscure artefact. In its new environment, it gains the appearance of a fragile museum piece and is afforded all the care and delicate handling that such a description invokes. How do these physical and descriptive shifts affect the 'truth' of the hut? Have all the original contents of the hut been left untouched? And if so, haven't they now fallen off the shelves?

Rob Kennedy

TORSTEN LAUSCHMANN

Let's Kiosk — 2000, 25 minutes

Photo © Torsten Lauschmann

WE PROCLAIM the old films, based on the romance, theatrical films and the like, to be leprous.

— Keep away from them!

— Keep your eyes off them!

— They're morally dangerous!

Contagious!

We affirm the future of cinema art by denying its present.

'Cinematography' must die so that the art of cinema may live. We call for its death to be hastened.

We protest against that mixing of the arts which many call synthesis. The mixture of bad colours, even those ideally selected from the spectrum, produces not white, but mud.

Synthesis should come at the summit of each art's achievement and not before.

We are cleansing kino-eye of foreign matter — of music, literature and theatre; we seek our own rhythm, one lifted from nowhere else, and we find it in the movements of things.

… For his inability to control his movements, we temporarily exclude man as a subject for film.

… The new man, free of unwieldiness and clumsiness, will have the light, precise movements of machines, and he will be the gratifying subject of our films.

… Kino-eye the art of organising the necessary movements of objects in space as a rhythmical artistic whole, in harmony with the properties of the material and the internal rhythm of each object.

Excerpts, Dziga Vertov, *We: Variant of a Manifesto*, 1922

Torsten Lauschmann

MARK LECKEY

Fiorucci made me hardcore — 1999, 15 minutes

SOME IMAGES of the late 70s/early 80s fashion movement called the 'casuals'. There are not many images available. If you know what you're looking for, you can see them in videos of crowd disturbances at British football matches of the period. At the time, the only people who recognised them as a cult were the police. They believed that the casuals' style was a ruse to disguise themselves and so not be identified as hooligans at the match. This was in some ways true. The casual's fashion was a guise, a means of seduction and guile. The Police fear of infiltration was exactly the effect the casuals wished to create.

Casuals dressed in luxurious sportswear with labels such as Ellesse, Cerrutti, Head and Lacoste. They also liked expensive golf wear: Pringle, Lyle & Scott, powder blue, lemon and pink pastel diamond patterned sweaters. Gathered together, dressed like east-coast preppies at a British football ground, their intention wasn't to blend in, but to disrupt and confuse. Their style was designed to dazzle, both with its luxury and displacement. In the glare, the casuals could move free and unhindered, like models shoplifting. To enable this shock of the new to remain powerful, casual fashion moved quickly, updating weekly. After the sportswear came the country look: Barbour jackets, tweed caps and deerstalkers. The country look was followed by a clever feint, a downturn to scruffy corduroy jackets, button-down Ben Sherman shirts and battered brogues, an academic and middle class look.

By the mid-80s the police had set up a football intelligence unit: a special force dedicated to classifying and documenting trouble-makers at the match. The police had a special van, the 'Hoolivan', which would drive through the crowds photographing possible 'top boys' and 'crews'. Through piecing together the evidence gathered along with extensive under cover operations, they began to identify and finally dismantle the strategies of the casuals. Within police archives then, lies testimony to one of the most sophisticated and aesthetically brilliant movements of the 20th century.

Mark Leckey

Hilary Lloyd

Rich — 1999, 4 minutes

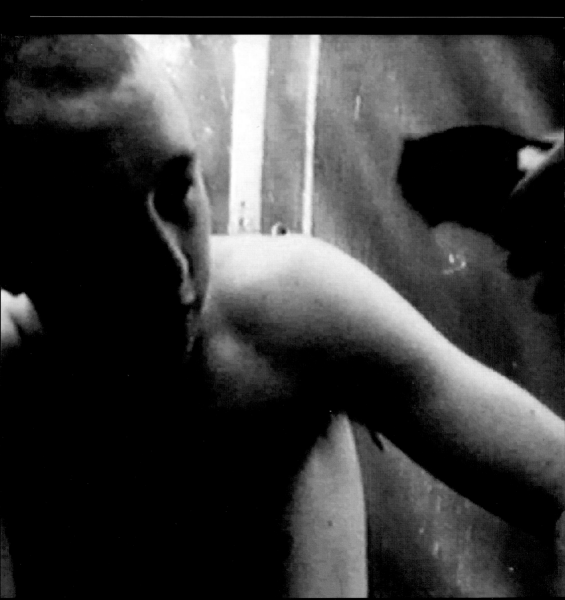

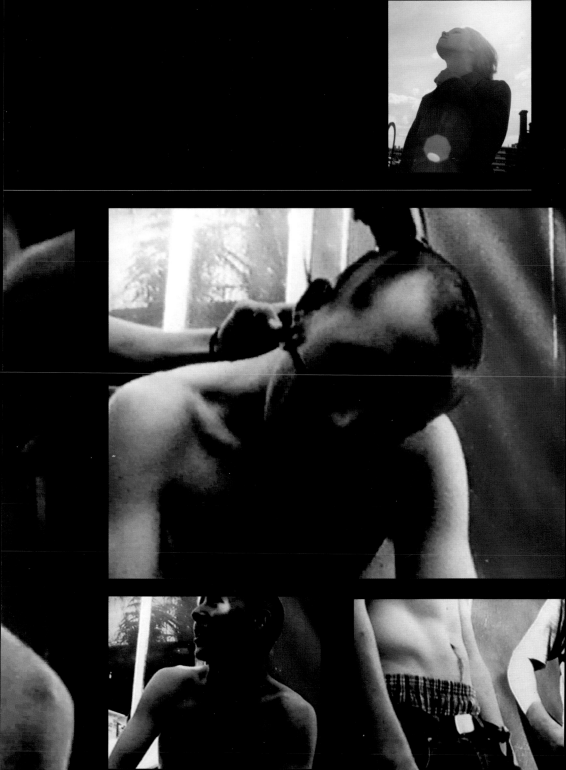

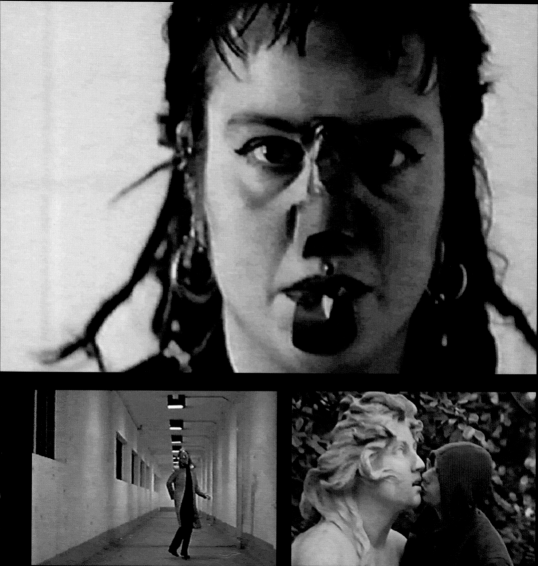

script we wanted to exhaust people — hurt their eyes and make them feel a little sick — but make the experience enjoyable. We used certain images from earlier works, like the line dancers from *House & Garage* (2000), to have fun with our aesthetic. *Mixtape* is a celebration of young people, but it also touches on the idea of what one critic called 'youth under siege by youth culture.' So Starbucks is 'cool' because they'll employ you even if you have any piercings, but they'll make you wear ludicrous hygienic blue bandages over them. Scooters are 'cool' because they're aimed at 'younglies,' twenty-somethings stuck in adolescence, but if you stick two kids on a scooter on a treadmill, they still ain't going nowhere. Our images are a 'fuck you' to corporate intervention in youth culture, whether it's hardcore, punk rock, skateboarding, graffiti, whatever. We wanted to celebrate the other to that: the pure, raw cane sugar.

After listening a lot to the Terry Riley song, we constructed a series of images and sequences that connected with these ideas and had a place within the music. Absurd or funny, poignant or romantic, we wrote them all down and assembled the best of them around the track. It's about fifty-fifty sound and vision. We tried to be aware of the music while we were editing. The strobe lights and the hunting scenes, for instance, begin just as the track goes mental. It would have been a drag to edit everything right on the beat. It's like a Krautrock record, a Neu! or Can track, in which a single phrase is repeated until it begins to generate new rhythms. The economy of the cuts in *Mixtape* is critical. The editing is crass at points, but we were mindful of a disjunction between sound and vision as well as a connection. *Mixtape* was shot on film, so it looks different from our previous work. We wanted it to look like a cross between an insurance ad and Schindler's list: heavy and ugly and stupid. But at times it also has a brash, colourful *Carry On* appearance to it. We didn't want to make another shaky hand-held film. The more we see films shot through plastic bags, the more we want to make refined, straight' classics.

There's a lot of dancing in *Mixtape*, for the simple reason that we love to see dancing on film. Dance is a primal celebration of life. In *House & Garage* we made the point that two kids playing bedroom DJs — what's called having a little rinse

dancing. Watching a good skateboarding video is like watching ballet — we interested in that kind of grace in movement and in different uses of space whether it's dancing with a partner at a community centre or making backside boardslides on a park bench.

There's an explicit reference to Huysmans' *Against Nature* in *Mixtape* that surprisingly few people picked up on: a young flaneur looking amazing outside a chip shop with his jewel-encrusted tortoise on a leash. Most of the other images are less academic. The old guy with the hammer is an homage to reggae legend Lee Perry, who crawled across Kingston, Jamaica on his hands and knees trying to chase Satan from the earth by banging the ground with a hammer. We just transported this character to Chiswick. As for the kids riding scooters on a rolling treadmill, there's a shop in London called Lillywhites that had an offer: if you bought a treadmill, they'd throw in a free scooter. They had it displayed in the window, a treadmill with a scooter sitting on top of it. It looked so amazingly stupid — we sat outside the shop just crying with laughter. Even if you hate it, you have to admit that *Mixtape* is full of the fucking brim.

(First published as 'A Thousand Words', *Artforum International*, September 2002)

Oliver Payne & Nick Relph

PAUL HOONEY

Around Between/Lights Go On — 2000, each film 3 minutes

MORE THAN half the image contains not much at all. The bottom of the photo is just a cobbled road. Above that is the pavement, then a tiny wall, on which sits a woman with legs crossed. She has a white T-shirt. Her trousers are brown. She sits her handbag on the wall. There are two more women who sit on the far right. The left one has a red top, the right one white and grey. They're not the intended subjects for this holiday snap, but they distract attention despite this. Behind the wall there is a massive fountain, covered with writhing bronze statues. Beyond the large fountain are some Roman ruins. It's hard to tell which ones, but I presume they are baths. They could be Diocletian's, close to the Termini. Above them is an empty chalk white sky. There are roadside bushes that lead out of our sight. Under them, distant people swarm towards us.

This photograph is from some negatives found in a Rome street in 1995. It has recently become one of the subjects of a video piece, 'Three photographs found in a street in Rome', three films incorporating a song written about each photo. For this photograph, the song is busked in the original location of the photo. The image partly reminds me of a happy residency in Rome 1995, and it also connects to the first album by my band Rooney made in 1998 — the song about the photo appeared on it. The photograph has gained an importance for me through my simply paying attention to it, and has been absorbed into my practice. This is despite my having no knowledge of when it was taken, and who the subject, or the taker of the photograph was. I have become absorbed to the extent of travelling to Rome in 2002 to recreate the photo as a video work. The piece pays obsessive attention to this discarded image of an unknown person, and respect to the genuine strangeness and unknowability of 'others', the ordinary as unfamiliar.

Paul Rooney

on Friday and Saturday nights,

inside a box with open hatch

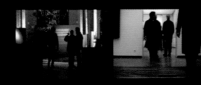

you dont get much chance to sit
while on the job

Lights go on

STEPHEN SUTCLIFFE

Please, Please, Please, Let Me Get What I Want — 2001, 2

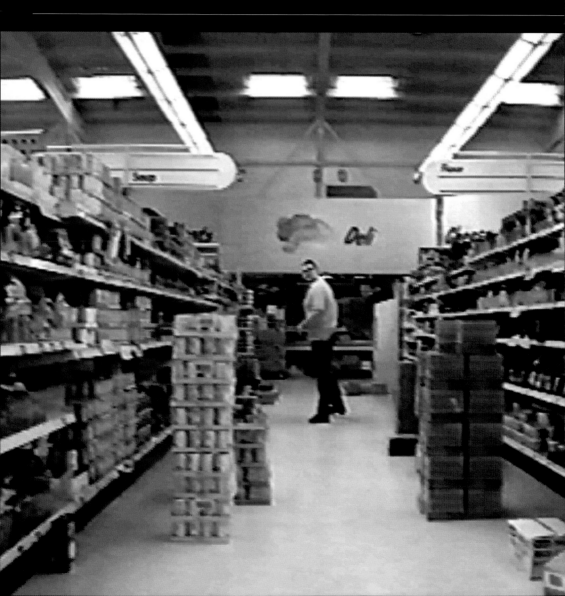

tes

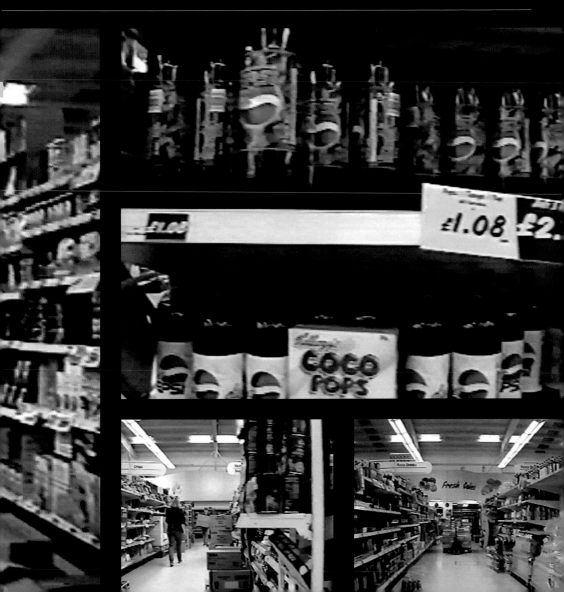

Szuper Gallery

Nirvana — 2002, 6 minutes

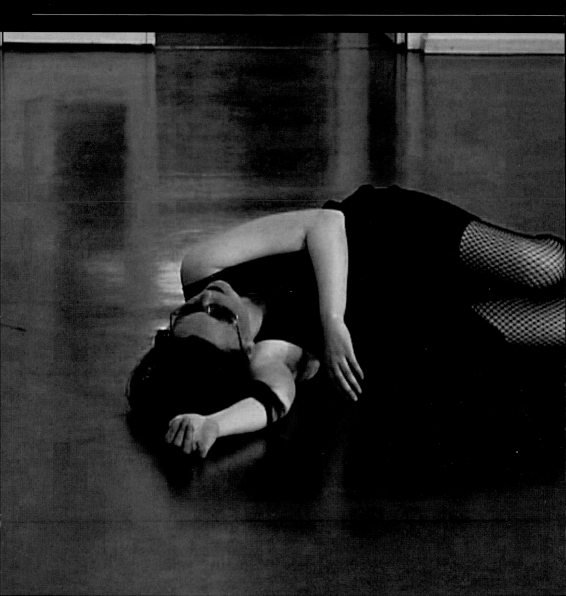

NOTES

4 … This collective 'mutating bureaucracy' allows the Szuper Gallery to explore whether new institutions from outside can be grafted onto the contemporary art world. Conflating the production and reception of art the Szuper Gallery maneuvers at boardroom level through various institutions such as Bloomberg Television, Christies and the Stock Exchange. Intricate activism highlights the thorny relationship between the cultural worker and culture broker. The weaving in and out of complicity with the corporate financiers through mobile tactics is integral part of the Szuper Gallery. These itinerant positions of 'self-institutionalization' are more than mere appropriation and subversive play. Just as the plans for the proposed nomadic Szuper Gallery indicate, the language, structure and elasticity of intent do not allow the crystallization of a self-sustainable institution By piggy backing existing institutions this fluid approach reaches different constituencies of people.

(Excerpt) *Alun Rowlands*

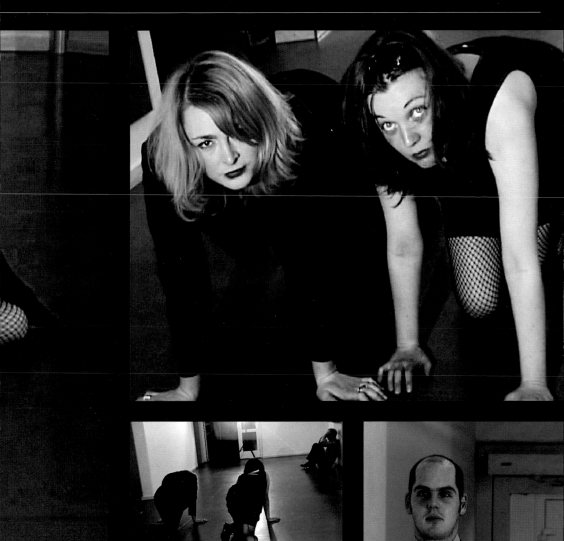

WOLFGANG TILLMANS

Lights (Body) — 2002, 6 minutes

Mark Titchner

Artists are Cowards — 2002, 10 minutes

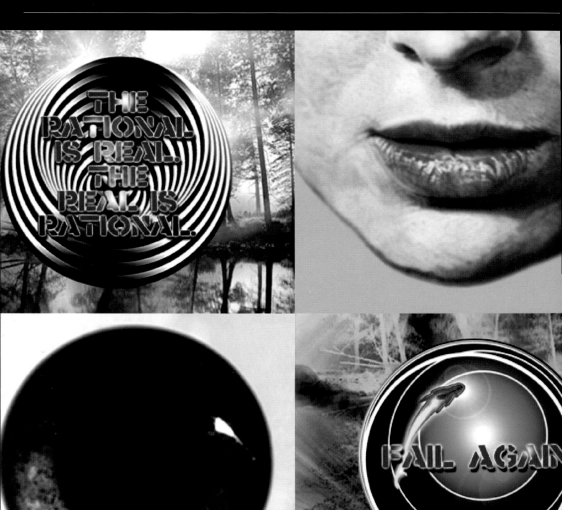

FRONT COVER of *Protest*, published by Quartet books, 1973. First published in Great Britain by Souvenir Press Ltd, 1959. Edited by Gene Feldman and Max Gartenberg. ISBN 0 704 31017 1. Published 1959, reprinted 1973, bought 2002.

I was born in 1973, at which point this text was in its middle age, radicalism moving inexorably towards inertia. When I bought the book in a charity shop on Rye Lane, it was nestled comfortably among the discarded set exam texts and the lovelorn Mills & Boons books. It now lives in-between *The Human cost of Nuclear War* and copies of *From Protest to Resistance* (the 'peace news' pamphlet). Most of my library has made a similar journey. I don't think this a bad thing, it just happens, it's the most inevitable dynamic in life.

Mark Titchner

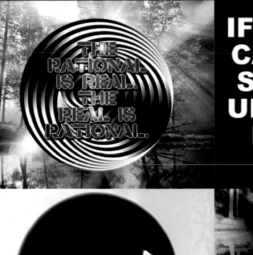

IF THE TRUTH CAN BE TOLD SO AS TO BE UNDERSTOOD IT WILL BE BELIEVED

TOMORROW IS A TRAVESTY

FAIL BETTER

LET THE COUNTERWEIGHTS BE REMOVED

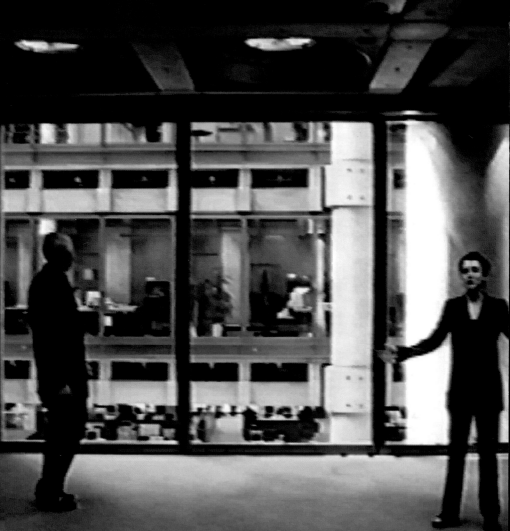

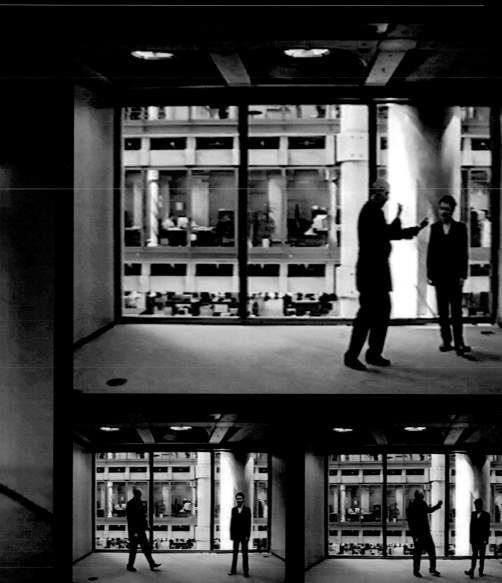

Biographical Information

ADAM CHODZKO

1965	Born in London
1985–88	University of Manchester
1992–94	Goldsmith's College, London
	Lives and works in Whitstable and London

Selected Solo Exhibitions

1996	Lotta Hammer, London
	Milch, London
1997	'Recall: Strange Child', Muf Hoxton, London
1998	Northern Gallery of Contemporary Art, Sunderland
	Viewpoint Gallery, Salford
1999	Galleria Franco Noero, Turin
	Ikon Gallery, Birmingham
2000	Accedemia Britannica, Rome
2001	Sandroni Rey Gallery, California
	Els Hanappe Underground, Athens
2002	Fabrica, Brighton
	Arizona State University Art Museum, Tempe
	Plains Art Museum, Fargo, North Dakota
	Cubitt, London

Selected Group Exhibitions

1992	'Instructions Received', Gio Marconi, Milan
1993	'Making People Disappear', Cubitt, London
	'Okay Behaviour', 303 Gallery, New York
	'Wonderful Life', Lisson Gallery, London
1994	'High Fidelity', Kohji Ogura Gallery, Nagoya
1995	'Every time I see you', Galleri Nicolai Wallner, Malmö
	'Zombie' Golf, Bank, London
1996	'General Release', British Council, Scoula San Pasquale, Venice
	'Brilliant', Walker Art Center, Minneapolis and tour
	'21 Days of Darkness', Transmission Gallery, Glasgow
1997	'It Always Jumps Back and Finds its Own Way', Stichting de Appel, Amsterdam
	'3 Wege zum see', Künstlerhaus Klagenfurt
	'Sensation', Royal Academy, London and tour
	'At one remove', Henry Moore Institute, Leeds
1998	'A to Z', The Approach, London
	'Real Life', Galleria S.A.L.E.S, Rome
	'Wrapped', Vestjælands Kunstmuseum, Soro
1999	'Sleuth', Ffotogallery, Cardiff and tour
	'The Poster Show', Gavin Brown Enterprises, New York
2000	'Dreammachines', Dundee Centre for Contemporary Art and tour

	'Found Wanting', The Contemporary, Atlanta
	'Artifice, Deste' Foundation, Athens
	'Black Box Recorder', Museum Ludwig, Cologne and tour
	'Face On', Site Gallery, Sheffield and tour
	'Places in Mind', Ormeau Baths Gallery, Belfast
2001	'Bright Paradise', 1st Auckland Triennial, Auckland Art Gallery
	'Night on Earth', Städtische Ausstellungshalle Am Hawerkamp, Münster
	'Liquor', Trafo Galeria, Budapest
	'Sacred and Profane', Mappin Art Gallery, Sheffield
2002	'Life is Beautiful', Laing Art Gallery, Newcastle upon Tyne
	'Tabu', Kunsthaus Basel
	'Private Views', London Print Studio
	'Location UK', Gimpel Fils, London
	'Fabrications', Cube Gallery, Manchester
	'Networks', Chapter Art Centre, Cardiff

VOLKER EICHELMANN & ROLAND RUST

Volker Eichelmann

1973	Born in Hamburg
1995–96	Chelsea School of Art, London
1996–98	St. Martins School of Art, London
1998–99	Goldsmith's College, London
	Lives and works in London

Roland Rust

1974	Born in Vienna
	Lives and works in Vienna

Selected Solo Exhibitions

1998	'Do You Really Want it That Much? … More!', Cubitt, London
1999	'StyleSubstance: The MaxMara Coat Project', MaxMara, London
	'Pantone Process Cyan', Kunstverein Wolsburg
2000	'Slug & Frisco', VTO, London

Selected Group Exhibitions

1996	'Treasure Trail Brixton', London
	'Romo-Night, 80s Retro from 90s London,' Jan-van-Eyck Academy, Maastricht
	'Tunnel Vision', Depot, Vienna
1997	'We gotta get out of this place', Cubitt, London
	'X squared', Secession, Vienna
	'Never forget that you are going to die', 810 Broadway,

New York
'Love is in the air: Love Lounge Hamburg', Kunstverein Hamburg
1998 'Fast Forward: trade marks, body check, archives', Kunstverein Hamburg
'Junge Szene '98', Secession Vienna
'Niet de kunst vlaai', W139, Amsterdam
'Sincerely yours', TED Gallery, Varna and tour
1999 'Moving Images, film — reflexionen in der kunst', Galerie für zeitgenössische Kunst, Leipzig
'Limit Less', Galerie Krinzinger, Vienna
'Village Disco', Cabinet Gallery, London
2000 'DEMOCRACY!', Royal College of Art, London
'[Working Title]', Stanley Packer Gallery, London
'Eine Munition unter anderen', Frankfurter Kunstverein
'Assembly', Stepney City, London
2001 'The seat with the clearest view', Grey Matter, Sydney
'Insider Trading', Mandeville Hotel, London
'New Releases', Art Gallery of New South Wales
'The Doughnut Concept', Britart.com Gallery, London
'Critical Video Lounge', York City Art Gallery
'Haus Wohner', Bluecoat Gallery, Liverpool
'Videonale IX', Bonn
2002 'Potential Hits', Chapman Gallery, Manchester
'No one ever dies there', no one has a head, hARTware Medien Kunstverein, Dortmund
'Arcadia in the city', Marble Hill House, London
'Am anfang war der skandal', Lehnbachhaus, Munich
'Blow up your TV!', York City Art Gallery

FOLK ARCHIVE (JEREMY DELLER & ALAN KANE)
Jeremy Deller
1966 Born in London
1985–88 Courtauld Institute of Art, London
1991–92 Sussex University
Lives and works in London

Alan Kane
1961 Born in Nottingham
1982–85 Canterbury College of Art
Lives and works in London

Selected Exhibitions/Projects
2000 'Heart of Glass', Cologne
'Intelligence: New British Art 2000', Tate Britain, London
2001 'The Battle of Orgreave', performance commissioned by

Artangel
2002 'After the Goldrush', an interactive guidebook to California
2003 'Art Concept', Paris

www.folkarchive.co.uk

LUKE FOWLER
1978 Born in Glasgow
1997–02 Duncan of Jordanstone College of Art, Dundee
Lives and works in Glasgow

Selected Solo Exhibitions
2000 'The Social Engineer', Transmission Gallery, Glasgow
'How Did You Get This Number?', Generator Projects, Dundee
2001 'UTO: The Technology of Tears', Casco Projects, Utrecht

Selected Group Exhibitions
2000 'Me We', Project Space, Athens
2001 'Beyond', Main Gallery, Dundee Contemporary Arts
'Recontres Video', Annecy
'Cinielingus', Catalyst Arts, Belfast
2002 'Fair', Royal College of Art, London
'Shadazz', 13th Note, Glasgow
'Koncentrat', Galleri Concentrat, Mellomvein
Manifesta 4, Frankfurt
'Agitate', Blitz Festival, Manchester

ROB KENNEDY
1968 Born in London
1987–90 Brighton Polytechnic
Lives and works in Glasgow

Selected Solo Exhibitions
2000 'Movers and Shakers', Transmission Gallery, Glasgow
'Death Cookies', Grizedale Arts

Selected Group Exhibitions
1999 'Remember Things Before They Happen', Glasgow Film and Video
'Monitoring', CCA, Glasgow
2000 'Memorial Imorial', Bulkhead, Glasgow
'The Truth and the Light', Werkleitz Gesellschaft
2001 'Metropolis', Rimusicazioni Festival

2002 'Fair', Royal College of Art, London

'The Listener is the Operator', CCA/Glasgow Art Fair

TORSTEN LAUSCHMANN

1970 Born in Bad Soden

1993–97 Glasgow School of Art

2000–01 Zentrum für Kunst und Medien, Karlsruhe

Lives and works in Glasgow

Selected Solo Exhibitions

1997 'Places of Exposure', The Cameo Visual Art Space, Edinburgh

1999 'Reduced Landscape', Kunstadapter, Wiesbaden

2000 'Four Short Films and Records from the Golden Age of Electronic Music', Belfast

2002 'Autumn Rhythm Film', Changing Room Gallery, Stirling Catalyst Gallery, Belfast

Selected Group Exhibitions

1996 'GSA One', Stirlings House, Tennessee

1997 'Hells Angels: Lapland Multiples Show', Glasgow

1998 'T Lauschmann/O Hartung', Künstlerhaus Ulm

'Zusammenhänge', Kunstadapter, Wiesbaden

'Kino', British Short Film Festival, Manchester

'Soup', Collective Gallery, Edinburgh

'Animals', Galerie Objektiv, Cologne

'Satan oscillate my metallic sonatas', Fly Gallery, Glasgow

1999 'Xn', B16, Birmingham

'Citizen 2000', Collective Gallery, Edinburgh

'What is is, what ain't ain't nothing', Fly Gallery, Glasgow

'Lunarova', Urania, Barcelona

Variant Summer Launch, Fruitmarket Gallery, Edinburgh

'Silver', Peacock Gallery, Aberdeen

'Departure Lounge', The Cameo Art Space, Edinburgh

'Museum Magogo', Glasgow Project Space

'Backlight,' International Triennale of Photography, Finland

'Jesus, Mary and Joseph', Stills Gallery, Edinburgh

2000 'Deep in this Custard', Changing Rooms, Stirling

'Modell, Modell', Kunstverein Aachen

'Sehnsucht nach Utopie', International Film & Photography Festival, Wiesbaden

'Country Casuals', B12, Birmingham

2001 C&H Photography Prize, Stills Gallery, Edinburgh

'O'Mara/Lauschmann', Old Museum Art Centre, Belfast

'New German Photography', De March-Solbiati, Milan

'Loox7', Wackergallerie, Darmstadt

'The International Language', Belfast

'Digital Bernd&Uschi supreme', Wiesbaden

'NOIR', Transmission Gallery, Glasgow

2002 'Shadazz', 13th Note, Glasgow

'Hegel and Meckbach', Frankfurt, Germany

'Fair', Royal College of Art, London

'Metallic K.O.', Nifca, Helsinki

MARK LECKEY

1964 Born in Liverpool

1987–90 Newcastle upon-Tyne Polytechnic

Lives and works in London

Selected Solo Exhibitions

1993 'The Model', San Francisco Art Fair

2000 'London, My Part in its Downfall', Galerie Daniel Buchholz, Cologne

Gavin Brown Enterprises, New York

2002 Cabinet, London

Gavin Brown Enterprises, New York

Selected Group Exhbitions

1990 ICA New Contemporaries, Institute of Contemporary Art, London

1996 Gavin Brown Enterprises, New York

1998 David Zwirner, New York

2000 'Crash', Institute of Contemporary Art, London

'Village Disco', Cabinet, London

'London Orphan Society', Openspace, Milan

Pitti Imagine, Florence

'Protest and Survive', Whitechapel Art Gallery, London

2001 'Century City', Tate Modern, London

'My Generation: 24 hours of video art', Truman Brewery, London

'Brown', The Approach, London

'Sound and Vision', Institute of Contemporary Art, London

'The Visitors', Théatres du Fantastique, Printemps du Septembre, Toulouse

2002 Santa Monica Museum of Modern Art, Los Angeles

'Remix', Tate Liverpool

'Electric Dreams', Barbican, London

HILARY LLOYD

1964 Born in Yorkshire

1984–87 Newcastle-upon-Tyne Polytechnic

Lives and works in London

Selected Solo Exhibitions

1995 Cultural Instructions, London

1996 '3 DJ Sculptures', Casco, Utrecht

1999 Chisenhale Gallery, London

2000 Kino der Dekonstruktion, Frankfurter Kunstverein

Selected Group Exhibitions

1993 'Making People Disappear', Cubitt, London

'Matter & Fact', The Collection Gallery, London

1994 'Something's Wrong', The Tannery, London

'Imprint '93', Cabinet, London

1995 'Imprint '93', City Racing, London

'Karaoke', South London Gallery

1996 'Once Removed', Laure Genillard Gallery, London

'June Trailers', L'Atalantique Café, Milan

'Life/Live', Musée d'Art Moderne, Paris

'Alex Katz, Hilary Lloyd, Chris Moore, Andy Warhol', Gavin Brown Enterprises, New York

'Against', Anthony d'Offay Gallery, London

1997 'Snowflakes Falling on the International Dateline', Casco, Utrecht

'Multiple Choice', Cubitt, London

'Some Kind of Heaven', Kunsthalle Nurnberg and tour

'Hilary Lloyd, Jeremy Deller, Nicholas Usansky', Cabinet, London

'Lovecraft', CCA Glasgow and tour

'Assuming Positions', Institute of Contemporary Art, London

'Paul Graham, Hilary Lloyd, Richard Phillips', Bronwyn Keenan Gallery, New York

1998 'Hilary Lloyd, Jemima Stehli, Brian Dawn Chalkley presents ...', City Racing, London

'Inbreeder', Collective Gallery, Edinburgh

'Camouflage 2000', Galerie Praz-Delavallade, Paris

'It Took Ages', Bricks 'n' Kicks, Vienna

'Accelerator', Southampton City Art Gallery and tour

'SuperNova', Stedelijk Museum Bureau, Amsterdam

1999 'Sweetie', The British School at Rome

'Video Room', L'espace lausannois d'art contemporain, Lausanne

'Go away: artists and travel', Royal College of Art, London

2000 'The British Art Show 5', City Art Centre, Edinburgh and tour

'Intelligence: New British Art 2000', Tate Britain, London

2001 'City Racing (A Partial Account)', Institute of

Contemporary Art, London

'The seat with the clearest view', Grey Matter, Sydney

'Video Evidence', Southampton City Art Gallery

'Videonale 9', Bonner Kunstverein

'ABBILD', Steirischer Herbst, Graz

2002 'Pause it', Gwangju Biennale

'Happy Outsiders', Galeria Zacheta, Warsaw

OLIVER PAYNE & NICK RELPH

Oliver Payne

1977 Born in London

1999–02 Kingston University, London

Lives and works in London

Nick Relph

1979 Born in London

1999–02 Kingston University, London

Lives and works in London

Selected Solo Exhibitions

2000 'Matthew Higgs Presents', Fig. 1, London

Selected Group Exhibitions

1999 'You Don't Know My Steeze', Kingston University, London

'The Giant Rock 'n' Roll Swindle', The Chamber of Pop Culture, London

2000 'Protest and Survive', Whitechapel, London

2001 '8th Annual New Toronto Works Show', Cinecycle, Toronto

'Altelier Something', London

'Pandaemonium', The Lux Centre, London

'All is Fair in Love and War', Rotterdam

'Andy Warhol and Sound and Vision', Institute of Contemporary Art, London

2002 'Beck's Futures 3', ICA, London

PAUL ROONEY

1967 Born in Liverpool

1986–89 Edinburgh College of Art

1989–91 Edinburgh College of Art

Lives and works in Liverpool

Selected Solo Exhibitions

1994 'Histories', Collective Gallery, Edinburgh

1997 'New Menus' (as Common Culture), Real Gallery, New York

1999 'Counter Culture' (as Common Culture), Cornerhouse, Manchester
'Common Culture Have Arrived' (as Common Culture), Gasworks, London
2001 'New Order' (as Common Culture), FLAT, New York
'At a Distance From', SMEC, Sheffield
'New Work', Dundee Contemporary Arts
2002 'Mappin Open Solo Shows', Mappin Gallery, Sheffield

Selected Group Exhibitions
1995 'On Stream', Bluecoat Gallery, Liverpool
'Foreign Bodies', Shiniuku Cultural Centre, Tokyo
1996 'Dead Sound; Art from Liverpool', Anyway Gallery, New York
'Code names', Three Month Gallery, Liverpool
'Showroom', Collective Gallery, Edinburgh
1997 'Absolut Lotto', Collective Gallery, Edinburgh
'Rumble In the Jumble', Catalyst Arts, Belfast
1998 'Ground', Catalyst Arts, Belfast
'Vision 21' (as Common Culture), The Tunnel, New York
'The Day the Music Died', Lubbock Arts Centre, Texas
'Faxe (n) Aus Liverpool', Jugend Art Galerie, Cologne
'Hardline', Catalyst Arts, Belfast
'Glitter', Bluecoat Gallery, Liverpool
'New British Art', The Webster Gallery, Santa Ana, California
1999 'East International' (as Common Culture), Norwich Gallery
'Perspective '99', Ormeau Baths Gallery, Belfast
'My Eye Hurts', Thread Waxing Space, New York
'Pixelvision', Royal Museum of Scotland, Edinburgh and tour
2000 'Party', Konstakuten, Stockholm
'Cool Green', MOCA, Washington DC
'Stoked', Kansas State University
'Sum of Parts', Fruitmarket Gallery, Edinburgh
2001 'Call me Sarajevo', Museum of Sarajevo
'Merry Movement', Laforet Museum Harajuku, Tokyo
'Record Collection', VTO, London
'Video Cuts — Gizmocaster.com', Centre Georges Pompidou, Paris
'Visionaria: videolanguages', International Video Festival, Teatro dei Rozzi, Siena
2002 'No Sleep 'Til Hammersmith', Central Space, London
'Potential Hits', Chapman Gallery, Salford University
'Artstream: Sound from Near and Far', Red House Centre, Sofia and tour

STEPHEN SUTCLIFFE
1968 Born in Harrogate
1995–98 Duncan of Jordanstone College of Art, Dundee
2000–02 Glasgow School of Art/Cal Arts, California
Lives and works in Glasgow

Selected Solo Exhibitions
2001 Els Hanappe Project Space, Athens
2002 Transmission Gallery, Glasgow

Selected Group Exhbitions
1999 'Accelerated Learning', Lower Gallery, Dundee
'Coming up for air', Cooper Gallery, Dundee
'Absolut Open', Inverleith House, Edinburgh
2000 'Flourish Nights', Flourish Studios, Glasgow
2002 'Fair', Royal College of Art, London

SZUPER GALLERY (SUZANNE CLAUSEN & PAWLO KERESTEY)
Suzanne Clausen
1967 Born in Munich
1988–94 Akademie der bildenden Künste, Munich
1997–99 Slade School of Fine Art, London
Lives and works in London

Pawlo Kerestey
1962 Born in Uzhgorod
1980–84 Academy of Fine and Applied Arts, Lviv
Lives and works in London

Selected Solo Exhibitions
1996 'Radical Chic', Galerie Szuper, Munich
1998 'Something Always Follows Something Else', Kunstpark Forum, Munich
'Szuper Gallery', 30 Underwood Street, London
2001 KünstlerHaus, Bremen
2002 'Gallery Fiction', KünstlerHaus, Bremen

Selected Group Exhibitions
1998 'Crystal State', 3 month Gallery, Liverpool
'On the Margins', Mendel Gallery, Saskatoon
1999 'Programme Fernsehen', Shedhalle, Zurich
'8th Biennale of the Moving Image', Centre for Contemporary Images, Geneva
'1st Toronto Video Biennale', Toronto
'Limit Less', Galerie Krinzinger, Vienna

'Dial M … for', Kunstverein, Munich

Crash!', Institute of Contemporary Art, London

2000 'Version 2000', Centre for Contemporary Images, Geneva

'Russia is Still Dangerous', Kunstverein, Munich

2001 'On The Margin', Plugin Gallery, Winnipeg

'(Un)cut Special Edition: Artists as Diplomats', Lux Gallery, London

'What's Wrong?', Trade Apartment, London

'Tele(visions)', Kunst sieht fern, Kunsthalle, Vienna

'Temporary Accomodation', Whitechapel Art Gallery, London

2002 'Am Anfang der Bewegung stand ein Skandal', Lenbachhaus München

'Another Swiss Version', AR/GE KUNST Museum, Bolzano

WOLFGANG TILLMANS

1968 Born in Remscheid

1990–92 Bournemouth and Poole College of Art and Design

Lives and works in London

Selected Solo Exhibitions

1988 'Approaches', Fabrik-Foto-Forum, Hamburg and Stadtbücherei Remscheid

1991 '2 Jahre Berlin', Grauwert Galerie, Hamburg

1992 'Diptychen 1990–1992', PPS Galerie F.C. Gundlach, Hamburg

1993 Ars Futura Galerie, Zürich

Maureen Paley Interim Art, London

1994 Galerie Thaddaeus Ropac, Paris

Daniel Buchholz, Cologne

Andrea Rosen Gallery, New York

1995 Neugerriemschneider, Berlin

Portikus, Frankfurt

Kunsthalle, Zürich

Regen Projects, Los Angeles

1996 Kunstverein Elsterpak, Leipzig

'Wer Liebe wagt lebt morgen', Kunstmuseum Wolfsburg, Wolfsburg

'Faltenwürfe', Daniel Buchholz, Cologne

Andrea Rosen Gallery, New York

1997 Galleria S.A.L.E.S, Rome

'I Didn't Inhale', Chisenhale Gallery, London

'Hale Bopp', Daniel Buchholz, Cologne

1998 'Fruiciones', Museo Nacional Centro de Arte Reina Sofia, Espacio Uno, Madrid

'Effects', Soho picturehouse, London

1999 'Wako Works of Art', Tokyo

'Eins istsicher: Es kommt immer ganz anders als man denkt', Städtische Galerie, Remscheid

'Soldiers/Space between two buildings', Maureen Paley Interim Art, London

Regen Projects, Los Angeles

2000 'Blushes', Fig. 1, London

Galerie Meyer Kainer, Vienna

Galerie Rüdiger Schöttle, Munich

2001 Andrea Rosen Gallery, New York

'Super Collider', Galerie Daniel Buchholz, Cologne

'Science Fiction/hier und zufrieden sein', Isa Genzken, Wolfgang Tillmans, Museum Ludwig, Cologne

'Aufsicht', Deichtorhallen Hamburg and tour

2002 'Partnerschaften', NGBK, Berlin

Regen Projects, Los Angeles

Maureen Paley Interim Art, London

'Lights (Body)', Galleria S.A.L.E.S, Rome

Sommer Contemporary Art, Tel Aviv

'Lights (Body)', Andrea Rosen Gallery, New York

Selected Group Exhibitions

1992 'I-D Now', Pitti Imagine, Palazzo Corsini, Florence

'Tomorrow People: I-D Now', Imagination Gallery, London

1993 'Phenylovethyalmour', Unfair 1993, Cologne

1994 'L'Hiver de l'Amour', Musée d'Art Moderne de la ville de Paris

'Soggetto, Soggetto', Castello di Rivoli, Torino

'Streetstyle', Victoria and Albert Museum, London

1995 'Take Me (I'm Yours)', Serpentine Gallery, London

'Human Nature', New Museum of Contemporary Art, New York

'The Enthusiast', Gavin Brown's Enterprise, New York

'Bildermonde-Modebilder: Deutsche Modephotographien von 1945–1995', Institut für Auslandsbeziehungen, Germany

1996 'Das deutsche Auge', Fotojournalism in Deutschland, Diechtorhallen, Hamburg

'New Photography at #12', The Museum of Modern Art, New York

1997 'Absolute Landscape: Between Illusion and Reality', Yokohama Museum of Art, Yokohama

'THE 90S: a Family of Man?', Casino Luxembourg — Forum d'Art Contemporain, Luxembourg

1998 'Fast Forward Image', Kunstverein, Hamburg
'White Noise', Kunsthalle, Bern
'The DG Bank Collection', Hara Museum of
Contemporary Art, Tokyo
1999 'On the Sublime', Rooseeum, Malmö
'Visions of the Body: Fashion or Invisible Corset',
National Museum of Modern Art, Tokyo
'Soldiers', Neuer Aachener Kunstverein, Aachen
Deichtorhallen, Hamburg
'Word enough to save a life, Word enough to take a life',
Clare College Mission Church, London
'6th Caribbean Biennial', The Golden Lemon, St. Kitts
2000 Turner Prize, Tate Britain, London
'Apocalypse: Beauty and Horror in Contemporary Art',
Royal Academy of Arts, London
'Protest and Survive', Whitechapel Art Gallery, London
'Eine Munition unter anderen', Frankfurter Kunstverein
'Complicity', Australian Centre for photography,
Sydney
'Dire AIDS: Art in the age of AIDS', Promotrice della
Bella Arte, Turin
'Deep Distance: Die Entfernung der Fotografie',
Kunsthalle Basel
'The British Art Show 5', organised by the Hayward
Gallery, Edinburgh and tour
'Quotidiana: The Continuity of the everyday in 20th
Century Art', Museo d'Arte Contemporanea, Rivoli
'Landscape', organised by The British Council, Weimar
and tour
2001 'Zero Gravity', Kunstverein der Rheinlande und
Westfalen, Kunsthalle Düsseldorf
'Century City: Art and Culture in the Modern
Metropolis', Tate Modern, London
'Uniforms, Order and Disorder', Pitti Immagine, Florence
and tour
'Record Collection', Forde Espace d'Art Contemporain,
Genève
2002 'Museum unserer wünsche, The Museum of our wishes',
Museum Ludwig, Cologne
'Transform the world 2002', Wako Works of Art, Tokyo
'Painted, Printed and Produced in Great Britain', Grant
Selwyn Fine Art, New York
'Remix: Contemporary Art and Pop', Tate Liverpool

MARK TITCHNER

1973 Born in Luton

1992–95 St. Martins School of Art, London
Lives and works in London

Selected Solo Exhbitions
1998 One in the Other, London
1999 Vilma Gold Gallery, London
2000 'Love, Work and Knowledge', Vilma Gold Gallery, London

Selected Group Exhibitions
1996 'BANK TV/Viper', DOG (BANK), London
'Life/Live', Musée d'Art Moderne, Paris
1997 'Pysionomical Corpus', One in the Other, London
'TransMat', One in the Other, London
'Recent Acquisitions', BUND, London
'High Precision/Low Maintenance', Hales Gallery, London
'Peripheral Visionary', De Fabriek, Eindhoven
'Show 47', City Racing, London
1998 'Sociable Realism', Stephen Friedman Gallery, London
'The Bible of Networking', Sali Gia, London and tour
'Show me the money 3', 8 Dukes Mews, London
'Kling Klang', HMS Liverpool in association with Tate
Liverpool
'Surfacing', Institute of Contemporary Art, London
'True Science', KX, Hamburg
'Social Security', Ex Teresa, Mexico City
1999 'Painting Lab', Entwistle, London
'The Poster Show', Gavin Brown Enterprises, New York
'297 x 210', Firestation, Dublin
'Cave', Sali Gia, London
'New Build,' Platform, London
'… Nice to Meet You, Kunstbunker, Nuremburg
'Limit Less', Galerie Krinzinger, Vienna
2000 'Mark Titchner & David Musgrave', Grey Matter, Sydney
'Point of View', Richard Salmon, London
'Insanity Benefit', Vilma Gold Gallery, London
'Heart & Soul', Sandroni Rey, Los Angeles
Multiples, Temple Bar Gallery, Dublin
'Very Nice Film Club', Vilma Gold Gallery, London
'Mark Titchner & Lena Seraphin', Sali Gia, London
2001 'Fear it, do it anyway', Vilma Gold Project Space, London
'Best Eagle', Transmission Gallery, Glasgow
'Curatorial Mutiny' Pt. 4, Nylon, London
'City Racing (A Partial Account)', Institute of
Contemporary Art, London
'Playing amongst the ruins', Royal College of Art, London
'Brown', The Approach, London

'Sages, Mystics & Madmen', One in the Other, London
2002 'Mathematique', Danielle Arnaud, London
'Loco for Rococo', The Nunnery, London
'Exchange', Richard Salmon, London
'Platforms', Jubilee Arts, West Midlands commission
'Strike', Wolverhampton City Art Gallery
'The Dirt of Love', The Mission, London
'Show', Royal Academy of Arts, London
'Talking Pieces', Museum Morsbroich, Leverkusen
'The Movement Began with Scandal', Lenbachhaus Museum, Munich

CAREY YOUNG

1970 Born in Lusaka
1989–92 University of Brighton
1995–97 Royal College of Art, London
Lives and works in London

Selected Solo Exhibitions
2000 'Nothing Ventured', Fig. 1, London
2001 'My Megastore', Virgin Megastore, London
'Business as Usual', John Hansard Gallery, Southampton and tour

Selected Group Exhibitions
1995 'Stream', Plummet, London
1996 'The Near and Far', British Pavillion, Milan Architecture Triennale
1998 'We Meet Beyond the Sea', Vernicos Centre for the Arts, Athens
'Wired/Elements', Zone Gallery, Newcastle
'Only Wankers Weep', The Tannery, London
'Zones of Disturbance', Marieninstitut, Graz
'Shine', National Museum of Photography, Film and Television, Bradford
'Outsiders', Center for Photography, Woodstock, New York
'Atomic', Imperial College of Science, Technology and Medicine, London
1999 'MayDay', The Photographer's Gallery, London
'CRASH!', Institute of Contemporary Art, London
'Exit: Art and Cinema at the end of the Century', Chisenhale Gallery, London
2000 'the.year.dot', Aspex Gallery, Portsmouth and tour
'Russia is Still Dangerous', Kunstverein, Munich and tour
'Continuum001', Centre for Contemporary Art, Glasgow
'Media Art 2000', Metropolitan Museum of Modern Art, Seoul Biennale
2001 'Look Out', Pitshanger Manor, London
'Nothing', Northern Gallery of Contemporary Art, Sunderland and tour
'The Doughnut Concept', Britart.com Gallery, London
'Tweener', Norwich Gallery
'The Communications Department', Anthony Wilkinson Gallery, London
'Without Dreams', Secession, Vienna
2002 'Exchange and Transform', Kunstverein Munich
'Panorama', Room Interior Products, New York
'The Passions of the Good Citizen', Apex Art, New York

Electric Earth

Exhibition Programme

Full exhibition running time: 3 hours, 15 minutes, 48 seconds

Published by the British Council
10 Spring Gardens, London SW1A 2BN

On the occasion of the International Touring Exhibition ELECTRIC EARTH
At The State Russian Museum, St. Petersburg, March 2003

Curators: Mark Beasley & Colin Ledwith
Assistant Curator: Katie Boot
Exhibition Architect: Stephen Beasley
Technical Manager: Gareth Hughes
Tour Manager: Louise Wright

Catalogue © British Council 2003
Texts © the credited authors 2003
Illustrations © the Artists except where credited
Artist portraits © Laurie Bartley except where credited
Catalogue Edited by Colin Ledwith
Catalogue Design: Robert Johnston
Video Grabs: Anne-Marie Copestake
Printed by: Beith Printing Ltd., Glasgow

All works © the credited Artists

Distributed by Cornerhouse Publications
70 Oxford Street, Manchester M1 5NH

ISBN: 0 86355 507 1

A catalogue record for this publication is available from the British Library

The publishers have made every effort to trace the copyright holders and apologise for any omissions that may have been made

With special thanks to:
Marcus Alexander, Dana Andrew, Matthew Arthurs, Anastasia Boudanoque, Roderick Buchanan, Francesca Canty, Kenneth Cappello, Tony Conner, Lorna Fleming, Ann Gallagher, Jemma Godfrey, Richard Gough, Ben Harman, Stella Harpley, Matthew Higgs, Hannah Hunt, Maria Kozlovskaya, James Lavender, Emily Newman, Maureen Paley, Clive Phillpot, Richard Riley, Polly Staple, Sam Walls, Toby Webster, Louise Wright, Lesley Young